Cats

in Spring
Rain

Cats
in Spring
Rain

A Celebration of
Feline Charm
in Japanese Art
and Haiku

TRANSLATED AND CURATED BY

Aya Kusch

CHRONICLE BOOKS
SAN FRANCISCO

Library of Congress Cataloging-in-Publication Data:
Names: Kusch, Aya, translator.
Title: Cats in spring rain : a celebration of feline charm in Japanese art
 and haiku / translated and curated by Aya Kusch.
Description: San Francisco, CA : Chronicle Books, [2022]
Identifiers: LCCN 2021048830 (print) | LCCN 2021048831 (ebook) |
 ISBN 9781797211749 (paperback) | ISBN 9781797213385 (ebook)
Subjects: LCSH: Japanese poetry—Translations into English. | Haiku—
 Translations into English. | Cats—Poetry. | Cats in art. | Art, Japanese. |
 LCGFT: Haiku. | Prints. | Paintings.
Classification: LCC PL782.E3 C38 2022 (print) | LCC PL782.E3 (ebook) |
 DDC 895.61008—dc23/eng/20211103
LC record available at https://lccn.loc.gov/2021048830
LC ebook record available at https://lccn.loc.gov/2021048831

Manufactured in China.

Design by Evelyn Furuta.

Cover art: *Japanese Ladies' Manners* / Ogata Gekkō / Arthur M. Sackler
Gallery, Smithsonian Institution, Washington, D.C.: Robert O. Muller
Collection, S2003.8.1746 (Detail)

10 9 8 7 6 5 4 3

Chronicle books and gifts are available at special quantity discounts to
corporations, professional associations, literacy programs, and other
organizations. For details and discount information, please contact our
premiums department at corporatesales@chroniclebooks.com or at
1-800-759-0190.

Chronicle Books LLC
680 Second Street
San Francisco, California 94107
www.chroniclebooks.com

Contents

Translator's Note • 9

Cats in Spring Rain • 14

The Poets • 109

The Artists • 117

Art Credits • 127

Translator's Note

In any conversation about haiku, it is important to first note the significance of seasons. Just about every haiku, whether it was written in the Edo period or penned the other day, has a seasonal reference called a *kigo*. Since cats' mating season is in early spring, cats themselves suggest early spring or the tapering off of winter.

Much like seasons, haiku represent a universal yet fleeting moment rooted in nature. They are not snapshots frozen in time, but rather, they flow into other moments and meditations. To represent this quality, I have omitted a capital at the beginning and a period at the end for each haiku. Indicating a beginning and an end would feel unfaithful to what I believe makes haiku a distinct and wonderful poetic form. The meanings of haiku are also meant to be open-ended, and by leaving out the period I am also allowing the haiku to remain open to further possibilities.

The chief reason for any divergences from the original haiku is the difference between the Japanese and English languages themselves. For example, in Japanese the verb often goes at the end, and so I have changed

the line order as needed to ensure that the haiku sound natural and make sense in as few words as possible. In addition, in English the concept of a 5-7-5 structure for haiku refers to syllables, whereas in Japanese it refers to sounds. There are more sounds than there are syllables in any given word or line of verse. Trying to force 17 syllables often requires adding unnecessary content, resulting in wordy haiku—not ideal for a poetic form known in large part for its brevity.

Haiku poets ask us to see the value within the everyday, within the ephemeral and seemingly simple. The cats in these haiku are less a metaphor and more a particularly expressive brushstroke, a single intuitive gesture that creates an image and conveys complex yet relatable feelings. My hope is that I have captured some of what makes these small moments with cats glimmer with specialness, what moved these haiku masters to turn them into art.

—AYA KUSCH, 2021

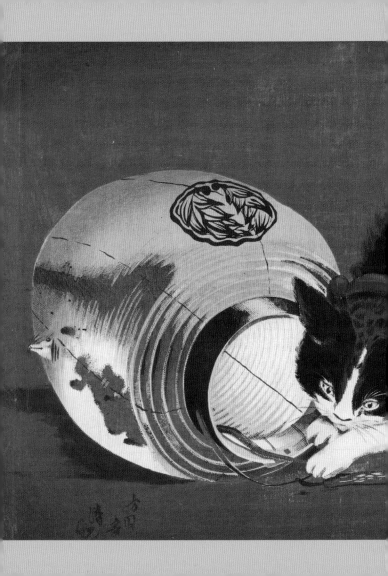

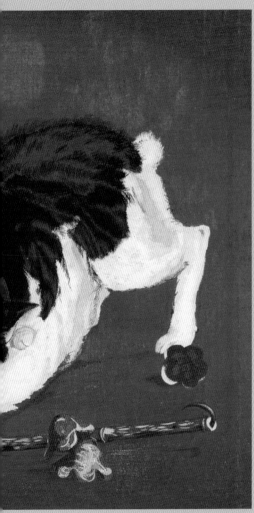

猫の鈴ぼたんのあっちこっち哉

neko no rin

botan no atchi

kotchi kana

cat's bell

here and there

in the peonies

—KOBAYASHI ISSA

春雨や猫におどりをおしえる子

harusame ya
neko ni odori o
oshieru ko

spring rain–
a child teaches
a cat to dance

—KOBAYASHI ISSA

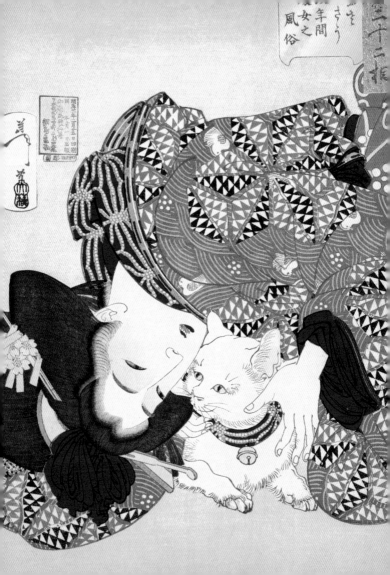

紅梅や縁にほしたる洗ひ猫

kōbai ya

heri ni hoshitaru

arai neko

beneath

the red-blossomed plum tree

a washed cat dries

—KOBAYASHI ISSA

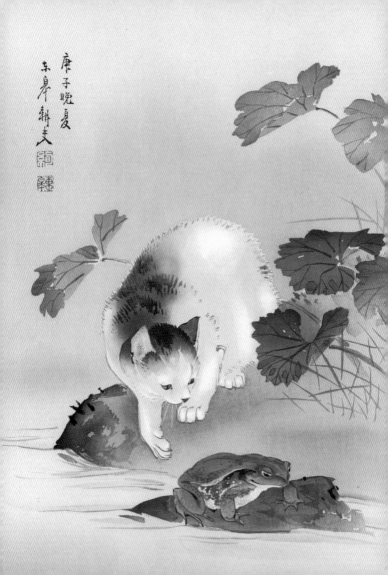

猫洗ふざぶざぶ川や春の雨

neko arau

zabu-zabu kawa ya

haru no ame

spring rain–

splashing around,

the cat washes in the river

—KOBAYASHI ISSA

猫の子のほどく手つきや笹粽

neko no ko no
hodoku tetsuki ya
sasa chimaki

small paws unravel

a bamboo leaf–

rice dumpling

—KOBAYASHI ISSA

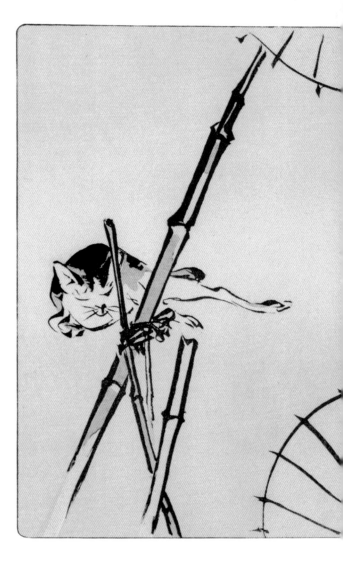

寝て起て大欠して猫の恋

nete okite

ōakubi shite

neko no koi

sleeping, then waking,

after a big yawn

the cat searches for love

—KOBAYASHI ISSA

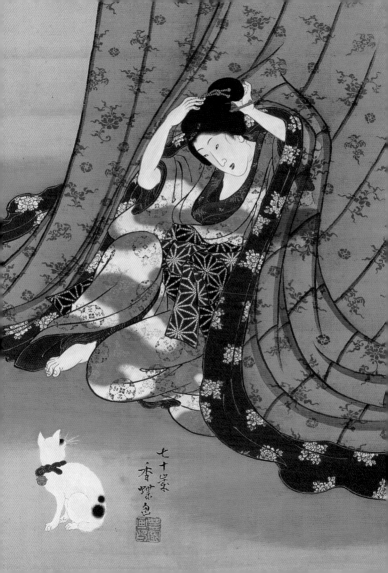

白猫のやうな柳もお花哉

shiro neko no

yōna yanagi mo

o-hana kana

white cat,

like a willow

or a noble flower

—KOBAYASHI ISSA

朝飯を髪にそよそよ猫の恋

asameshi o
kami ni soyo-soyo
neko no koi

breakfast rice lightly

dotting his whiskers—

a cat in love

—KOBAYASHI ISSA

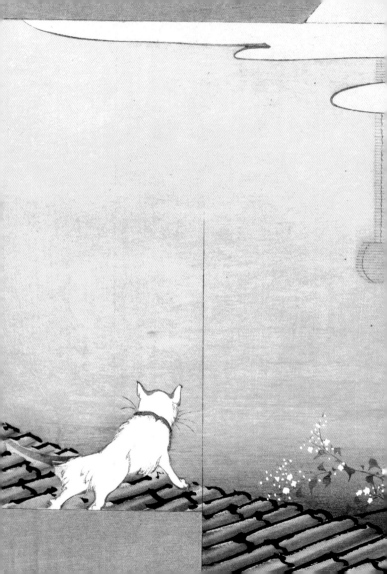

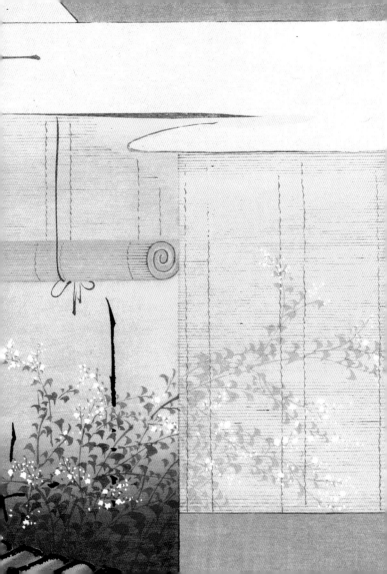

雪ふりや棟の白猫聲ばかり

yukifuri ya

mune no shironeko

koe bakari

snow is falling—

from the rooftop

the sound of a white cat

—MASAOKA SHIKI

のら猫が仏のひざを枕哉

noraneko ga

hotoke no hiza o

makura kana

a cat adrift

finds a pillow

on the Buddha's lap

—KOBAYASHI ISSA

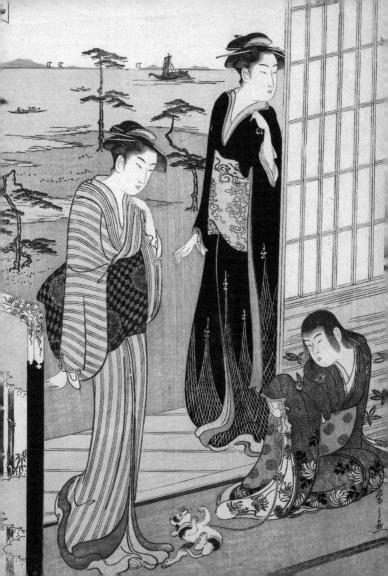

猫なくや中を流るる角田川

neko naku ya

naka o nagaruru

sumida-gawa

the Sumida river

flowing between them,

the cats call and cry

—KOBAYASHI ISSA

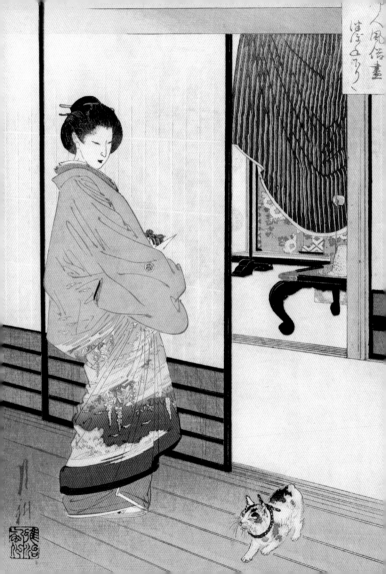

さ筵や猫がきて来た太平雪

samushiro ya

neko ga kite kita

tabira yuki

woven straw mat—

the cat comes in dusted

with snowflakes

—KOBAYASHI ISSA

49

寝並んで小蝶と猫と和尚哉

ne narande

kochō to neko to

oshō kana

lying down for a nap

a small butterfly, a cat,

and a high priest

—KOBAYASHI ISSA

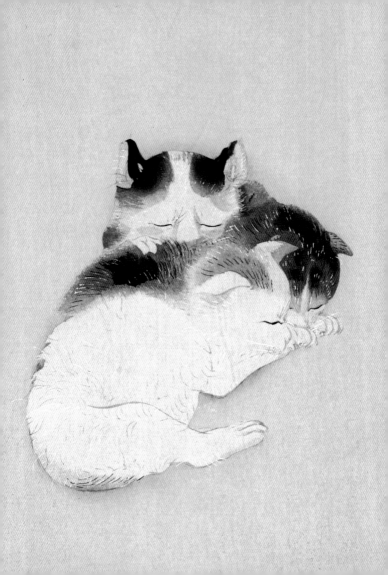

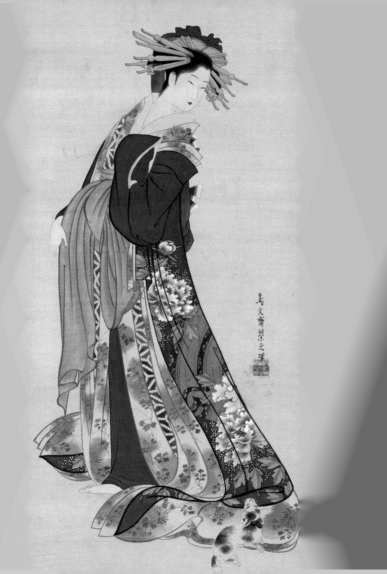

内のチョマが隣のタマを待つ夜かな

uchi no Choma ga
tonari no Tama o
matsu yoru kana

my cat Choma

waits all night

for the neighbor cat Tama

—MASAOKA SHIKI

おそろしいや石垣崩す猫の恋

osoroshi ya

ishigaki kuzusu

neko no koi

how terrible!

cats in love tear down

the stone wall

—MASAOKA SHIKI

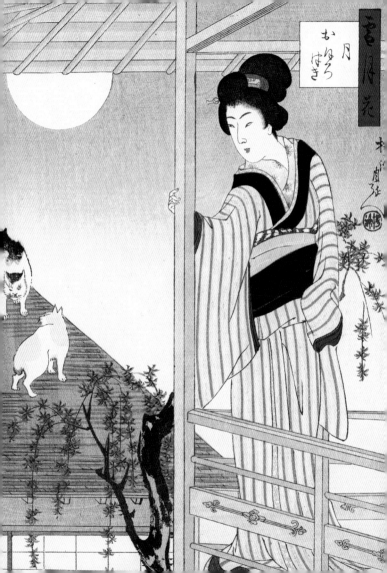

恋しらぬ猫や鶉を取らんとす

koi shiranu
neko ya uzura o
torantosu

a stranger to love,

the cat is about to catch

a quail

—MASAOKA SHIKI

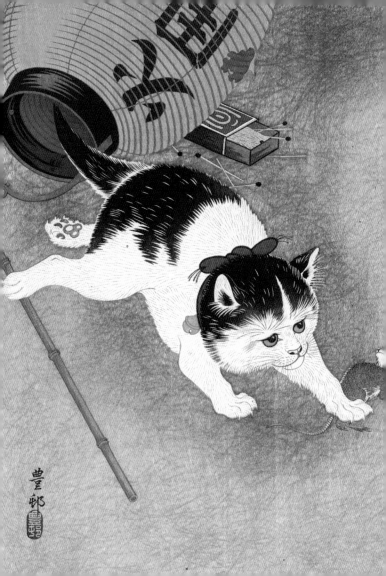

麦飯にやつるる恋か猫の妻

mugimeshi ni
yatsururu koi ka
neko no tsuma

the female cat

grown thin from love,

barley, and rice

—BASHŌ

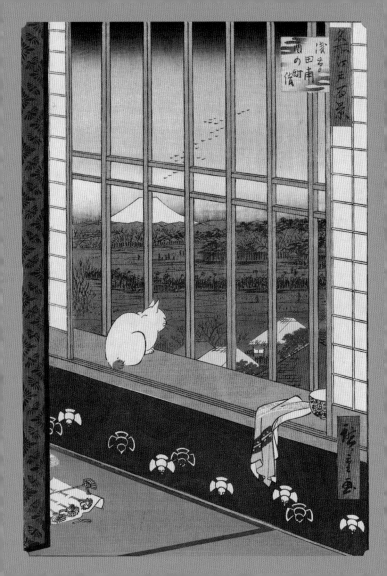

山は猫ねぶりて行くや雪の隙

yama wa neko

neburite iku ya

yuki no hima

like a cat's licked fur,

some snow remains

in the mountain crevices

—BASHŌ

張抜きの猫も知るなり今朝の秋

harinuki no

neko mo shiru nari

kesa no aki

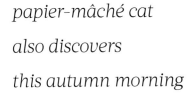

papier-mâché cat

also discovers

this autumn morning

—BASHŌ

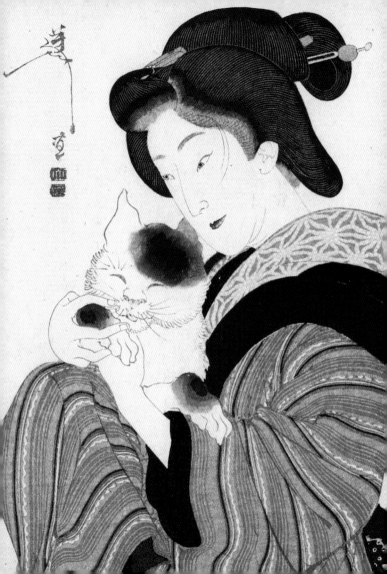

陽炎に何やら猫の寝言哉

kagerō ni nani

yara neko no

negoto kana

shimmer of heat

the cat murmurs

in his sleep

—KOBAYASHI ISSA

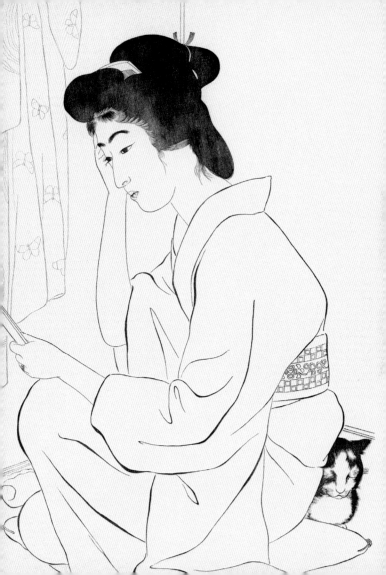

声たてぬ時かわかれぞ猫の恋

koe tatenu
toki ka wakare zo
neko no koi

silently,

the cats in love

depart

—CHIYO-NI

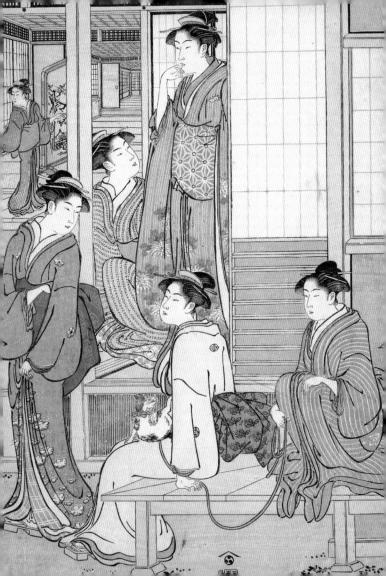

火燵のすそをのぞくから猫

kotatsu no suso o
nozoku karaneko

*under the kotatsu**

the Chinese cat

takes a peek

—CHIYO-NI

*A low table covered by a blanket with a heat
source underneath.

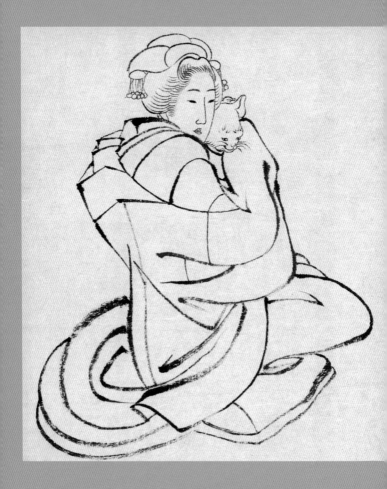

髭につく飯さへ思へず猫の恋太紙

hige ni tsuku

meshi sae omoezu

neko no koi

the cat in love

forgetful of even

the rice on his whiskers

—TAN TAIGI

屋根に寝る主なし猫や春の雨

yane ni neru

nushi nashi neko ya

haru no ame

stray cat

asleep on the roof—

spring rain

—TAN TAIGI

80

夕貌の花噛ム猫や余ごころ

yūgao no

hana kamu neko ya

yoso-gokoro

heart elsewhere,

a cat chews

on a moonflower

—YOSA BUSON

立多以盡

人あり如何なる猫の恋。と故人もひゞ
樹も盛の侯く頃。隅田の上流の
足もと暗き腕月に。顔をそむそ
へ。浮雲くわる糸瓜を。研や遂
ひるゝつ辛らふ狂ふ気中残。
これでも最う假名讀の先生
情あらん雲いさん

鶯〜堂文戯誌

牡丹やしろがねの猫こがねの蝶

botan ya

shirogane no neko

kogane no chō

peonies,

a silver cat,

a golden butterfly

—YOSA BUSON

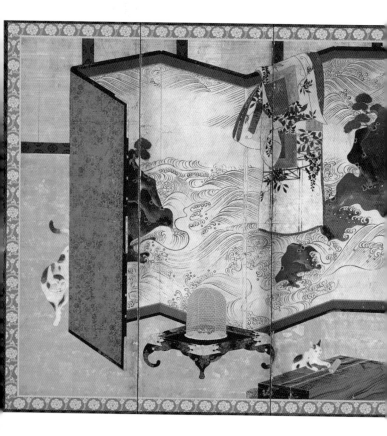

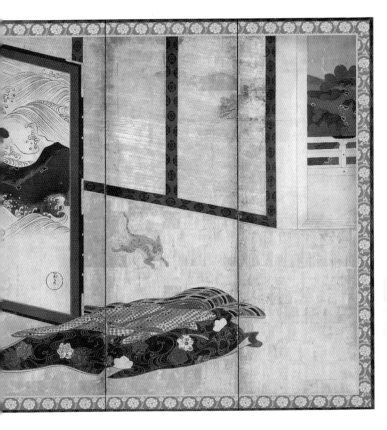

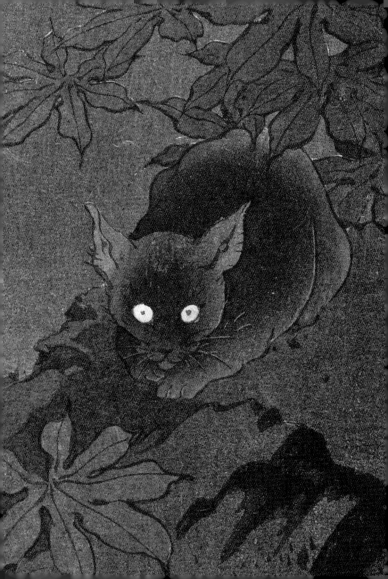

里の子の猫加へけり涅槃像

sato no ko no

neko kuwaekeri

nehanzō

reclining buddha–

the village child

has added a cat

—NATSUME SŌSEKI

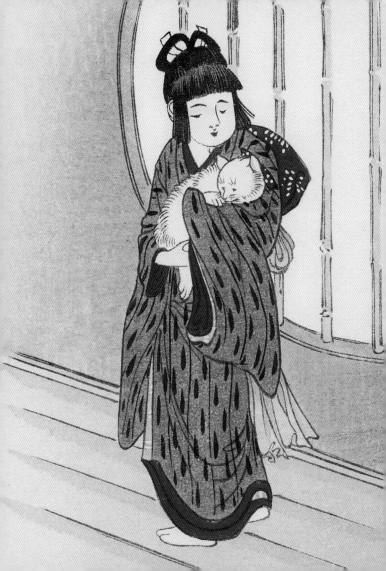

いとど鳴き猫の竈にねむる哉

itodo naki

neko no kamado ni

nemuru kana

crickets chirp

while the cat sleeps

beside the wood stove

—UESHIMA ONITSURA

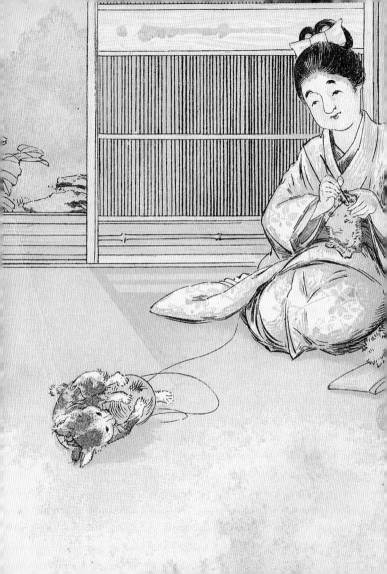

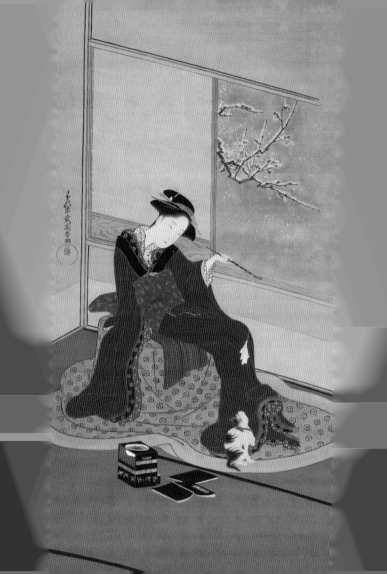

人声なつかしがる猫とおり

hitogoe
natsukashigaru
neko to ori

with a cat
growing wistful for
the voices of people

—SANTOKA TANEDA

うらやまし思ひ切る時猫の恋

urayamashi
omoikiru toki
neko no koi

it is enviable

how easily

cats give up on love

—OCHI ETSUJIN

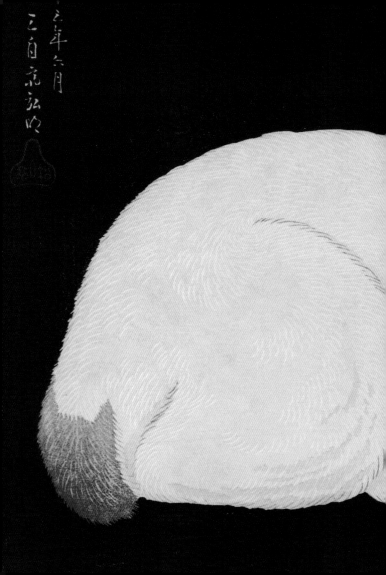

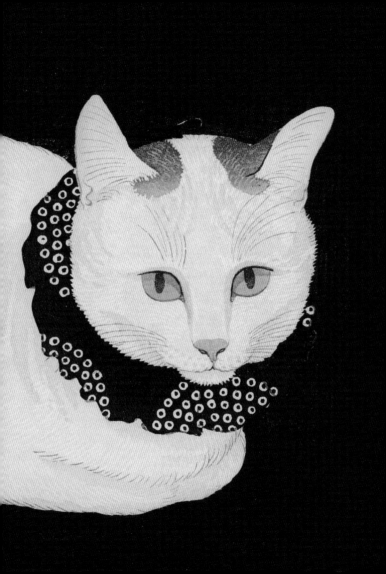

The Poets

Fukuda Chiyo-ni (1703–1775) grew up in a small town at the foot of a grand mountain, in a family of scroll-makers. This gave her early exposure to haiku, and by the time she was sixteen she was declared a haiku expert by a famous poet. She eventually became a nun, although she still kept a home outside of the temple, traveled often, and stayed immersed in literary circles. She was admired both for staying dedicated to her haiku despite women being discouraged from creativity and education, and for living the Way of Haikai.

Kaigai Tennen (active 1890–1900) was a Meiji era artist who created woodblock prints, along with the occasional kimono design, often featuring birds and beasts.

The Poets

Kobayashi Issa (1763–1827) was born in a small mountain village in central Japan, the son of a widowed farmer. At twenty-five he began to pursue his studies of haiku, and four years later, he decided to dress as a priest and began a life of travel. After the death of his father, he returned to the mountain village, where he spent the remainder of his days.

Masaoka Shiki (1867–1902) was born into a low-ranking samurai family. At eighteen he began to write haiku and eventually left school to pursue a career as a writer and editor of haiku. He developed the idea of *shasei*, sketching from life, and is often cited as the father of modern haiku.

Matsuo Bashō (1644–1694) drew from his practice of Zen, his knowledge of Chinese poetry, and his reverence for nature to craft haiku that were groundbreaking during his time. He is credited with turning haiku into a serious art form, and he mentored over seventy students and had hundreds of followers. He is now recognized as a *haisei*, a saint of haiku.

Natsume Sōseki (1867–1916) is regarded as one of the greatest novelists of the Meiji era, but he was also a scholar of British literature and a haiku poet. One of his most popular novels, *I Am a Cat*, parodies the lives of upper-middle-class Japanese society from the perspective of a cat.

The Poets

Ochi Etsujin (1656–1739) was born in Northern Echigo but spent much of his life in Nagoya. He was a disciple and friend of Bashō's and even accompanied him on his travels.

Santoka Taneda (1882–1940) was born in rural Japan to a wealthy landowner. He was a restless wanderer and devout Buddhist monk but also loved to surround himself with other poet friends.

Tan Taigi (1709–1771) was known for his rich social life, full of friendship and parties and plenty of sake. He was introduced to the haiku world through Masaoka Shiki and was a friend of Yosa Buson. He was also dedicated to his Buddhist practice, becoming a priest at age forty.

Ueshima Onitsura (1661–1738) was born into a family of brewers and began to show an aptitude for poetry at the age of eight. He moved to Osaka to dedicate himself to the study of haiku, becoming a renowned poet in the region. He was also highly influential in refining Bashō's style of haiku.

Yosa Buson (1716–1783) made his living by being a painter, but he also loved poetry and learned haiku in the tradition of Bashō. In the later years of his life, he emerged as a leader in the poetry community in Kyoto. During his final days he spoke of his appreciation of Bashō and wrote his last poem at the end of winter, about the onset of spring.

The Artists

Chōbunsai Eishi (1756–1829) was a vassal of the Shogunate but left his position in order to pursue a career in art. He became renowned for his exquisite depictions of women, and gained notoriety for his rivalry with a fellow artist, Utamaro.

Hashiguchi Goyō (1880–1921) was the son of a painter and began his own art practice at the age of ten. He graduated at the top of his class from Tokyo School of Fine Art and later became renowned for his dedication to craftsmanship and technical precision.

Katsushika Hokusai (1760–1849) was raised by an uncle who worked as a mirror polisher for wealthy families. Although Hokusai was meant to follow in his uncle's footsteps, he decided to dedicate himself to travel and art instead. He is said to have created thirty thousand pieces during his lifetime and is perhaps best known for his series *Thirty-Six Views of Mount Fuji*.

The Artists

Katsukawa Shunchō (1743–1793) founded the Katsukawa School, which had a particular interest in realism. He educated many of the great *ukiyo-e* artists and is known primarily for his portraits of beautiful women and kabuki actors.

Kobayashi Kiyochika (1847–1915) was a Japanese printmaker who captured the rapid modernization of Meiji Japan and the Western influence on the East. Later in life he turned his attention to illustration, with a focus on current events and military campaigns.

Ogata Gekkō (1859–1920) had no formal art training and began his artistic career by creating illustrations for books and newspapers. Later he pursued other mediums and became known for merging different art styles. He was a member of the Meiji Fine Art Society and a cofounder of the Japan Youth Painting Organization.

Ohara Koson (1877–1945) was a teacher at Tokyo School of Fine Arts as well as an artist. During his career, he collaborated with multiple publishers and exhibited extensively abroad. He is known for his depictions of animals and landscapes.

Oide Toko (1836–1903) adhered to the *Nanga* school of painting, which took Chinese painting as its model and was meant to be scholarly in nature. Several of his works now reside in the Imperial Household collection.

Shibata Zeshin (1807–1891) was the son of a craftsman and began his artistic practice at a young age. Along with being an artist, he also dedicated himself to his studies of haiku, the tea ceremony, and literature. He is also highly regarded for his lacquer decoration.

The Artists

Shōda Kōhō (1871–1946) was a Meiji-era artist whose lovely woodblock prints primarily featured landscapes, often at night or dusk.

Takahashi Shōtei (1871–1945) was a cofounder of the Japan Youth Painting Society and contributed to the *shin-hanga* movement. He was a prolific artist, creating around five hundred designs by the time he was fifty. Many of these were destroyed in a fire following the Great Kanto Earthquake. However, he never grew discouraged and continued to produce art, leaving behind two hundred fifty prints.

Takeuchi Seihō (1864–1942) was an artist and educator living in Kyoto. He toured Europe and studied Western art, and upon his return to Japan, he helped found the *nihonga* art style. Later in life, he was awarded the prestigious Order of Culture, which is given out by the emperor to those who have made significant contributions to Japanese culture.

Toyohara Chikanobu (1838–1912) was born in Niigata prefecture, spent his early years as a samurai, and even joined an elite samurai brigade during the Meiji Restoration. As the Shogunate fell, he began to pursue art and became a printmaker and illustrator, depicting a range of subjects from battlefields to women's fashion.

Tsukioka Yoshitoshi (1839–1892) began to exhibit artistic talent at a young age and at only eleven he began to study under Kuniyoshi. His work frequently reflects the political upheaval Japan went through during his time, and he is often considered to be one of the last great ukiyo-e masters.

The Artists

Utagawa Hiroshige (1797–1858) was the son of a fireman, and it is said that his first art teacher was a colleague of his father. He grew up to become a fireman himself but decided to take up art alongside his professional responsibilities. He became known as one of the great masters of the ukiyo-e genre, and his art became influential both throughout Japan and the West.

Utagawa Kunisada (1786–1865) was the son of a successful poet and discovered his affinity for art in early childhood. His favorite subjects were Kabuki actors, Samurai, and sumo wrestlers, and he even provided illustrations for Murasaki Shikibu's celebrated novel, *The Tale of Genji*.

Art Credits

PAGES 14–15

CAT WITH LANTERN
Kobayashi Kiyochika / Arthur
M. Sackler Gallery, Smithsonian
Institution, Washington, D.C.: Robert
O. Muller Collection, S2003.8.1151

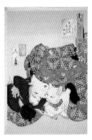

PAGE 20

TEASING THE CAT
Tsukioka Yoshitoshi / Image
copyright © The Metropolitan Museum
of Art. Image source: Art Resource, NY

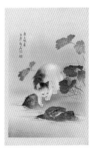

PAGE 23

A CAT TEASING A BULLFROG
Oide Toko / Arthur M. Sackler Gallery,
Smithsonian Institution, Washington,
D.C.: Robert O. Muller Collection,
S2003.8.2109

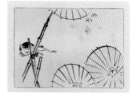

PAGES 28–29

CAT, UMBRELLAS, AND BUTTERFLIES
Shibata Zeshin / Arthur M. Sackler Gallery, Smithsonian Institution, Washington, D.C.: Gift of William E. Harkins, S1996.85.11

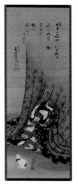

PAGE 31

COURTESAN BENEATH A MOSQUITO NET *(DETAIL)*
Utagawa Kunisada / Freer Gallery of Art, Smithsonian Institution, Washington, D.C.: Purchase — Harold P. Stern Memorial Fund, F1995.17

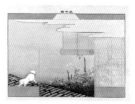

PAGES 36–37

PAGE FROM A BOOK OF KIMONO DESIGNS
Kaigai Tennen / Arthur M. Sackler Gallery, Smithsonian Instutition, Washington, D.C.: Robert O. Muller Collection, S2003.8.423

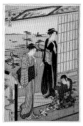

PAGE 42

GENJI IN EXILE AT SUMA
Chōbunsai Eishi / Image copyright ©
The Metropolitan Museum of Art.
Image source: Art Resource, NY

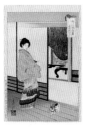

PAGE 46

JAPANESE LADIES' MANNERS
Ogata Gekkō / Arthur M. Sackler
Gallery, Smithsonian Institution,
Washington, D.C.: Robert O. Muller
Collection, S2003.8.1746

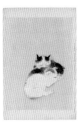

PAGE 53

TWO CATS
Takeuchi Seihō / Arthur M. Sackler
Gallery, Smithsonian Institution,
Washington, D.C.: Robert O. Muller
Collection, S2003.8.2454

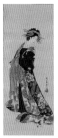

PAGE 54

OIRAN AND CAT
Chōbunsai Eishi / Freer Gallery of Art, Smithsonian Institution, Washington, D.C.: Gift of Charles Lang Freer, F1898.117

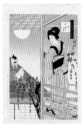

PAGE 57

OBOROZUKI
Toyohara Chikanobu / Arthur M. Sackler Gallery, Smithsonian Institution, Washington, D.C.: Robert O. Muller Collection, S2003.8.2577

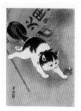

PAGE 60

CAT AND MOUSE
Ohara Koson / Arthur M. Sackler Gallery, Smithsonian Institution, Washington, D.C.: Robert O. Muller Collection, S2003.8.2073

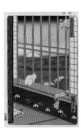

PAGE 64

ASAKUSA RICEFIELDS AND TORINOMACHI FESTIVAL
Utagawa Hiroshige / Freer Gallery of Art Study Collection, Smithsonian Institution, Washington, D.C.: Gift of Alan, Donald, and David Winslow from the estate of William R. Castle, FSC-GR-74

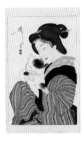

PAGE 69

WOMAN HOLDING CAT
Tsukioka Yoshitoshi / Arthur M. Sackler Gallery, Smithsonian Institution, Washington, D.C.: Robert O. Muller Collection, s2003.8.3077

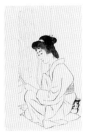

PAGE 71

POCKET MIRROR
Hashiguchi Goyō / Arthur M. Sackler Gallery, Smithsonian Institution, Washington, D.C.: Robert O. Muller Collection, S2003.8.114

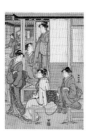

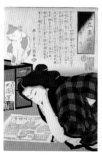

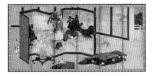

PAGES 88–89

WHOSE SLEEVES?
Artist unknown / Freer Gallery of Art,
Smithsonian Institution, Washington,
D.C.: Gift of Charles Lang Freer,
F1907.127

PAGE 90

CAT AT NIGHT *(DETAIL)*
Shōda Kōhō / Arthur M. Sackler
Gallery, Smithsonian Institution,
Washington, D.C.: Robert O. Muller
Collection, S2003.8.2240

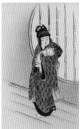

PAGE 95

**YOUNG GIRL WITH CAT BY THE
WINDOW**
Artist unknown / Photograph © 2022
Museum of Fine Arts, Boston

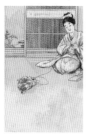

PAGE 99

YOUNG WOMAN KNITTING, WITH PLAYFUL CAT
Artist unknown / Photograph © 2022
Museum of Fine Arts, Boston

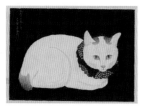

PAGE 100

INTERIOR: A GIRL AND A KITTEN
(DETAIL)
Katsukawa Shunchō / Freer Gallery
of Art, Smithsonian Institution,
Washington, D.C.:Gift of Charles Lang
Freer, F1903.132

PAGES 104–105

WHITE CAT
Takahashi Shōtei / Arthur M. Sackler
Gallery, Smithsonian Institution,
Washington, D.C.: Robert O. Muller
Collection, S2003.8.4215